Speak up for Life

Unforgettable Places *and* People to Remember

Sheryl Ende

WestBow Press books may be ordered through booksellers or by contacting:

WestBow Press
A Division of Thomas Nelson & Zondervan
1663 Liberty Drive
Bloomington, IN 47403
www.westbowpress.com
844-714-3454

ISBN: 978-1-6642-9321-2 (sc)
ISBN: 978-1-6642-9322-9 (e)

Library of Congress Control Number: 2023903201

Print information available on the last page.

WestBow Press rev. date: 03/08/2023

Dedicated to

Bert and Willy Dorenbos

Table of Contents

Endorsements ..vii

Acknowledgements ...xi

Foreword by Bert Dorenbos..xii

Introduction ...xiii

Part 1: Focus on Israel and the Holocaust1

 Chapter 1: UNFORGETTABLE PLACES AND A
 PEOPLE TO REMEMBER3

 Chapter 2: THE HIDING PLACE ..8

 Chapter 3: WESTERBORK INTERNMENT CAMP19

 Chapter 4: AUSCHWITZ-BIRKENAU CONCENTRATION CAMP......26

 Chapter 5: YAD VASHEM ... 45

Part 2: Widening the Scope ... 55

 Chapter 6: T4 PROGRAM...57

 Chapter 7: THE UNDERGROUND RAILROAD............... 64

 Chapter 8: THE COVENANT OF THE FIRST PEOPLES...................73

 Chapter 9: SPEAK UP FOR LIFE.. 86

About the Author .. 89

Endorsements

Allan Parker, President of The Justice Foundation
https://thejusticefoundation.org
The message of this book is clear, and compelling. Life matters! Human life must be valued and protected in culture and law from conception till natural death. Compelling pictures and stories make this accessible to high school students and adults.

Janice Huse, Artist
www.janicehuse.com
Speak Up For Life is a unique and wonderfully inspired teaching tool in the form of a book which I highly recommend for both student and parent alike. Securely based on a scriptural foundation, it provides a clever format in which to present true stories of real life heroes of the faith. They are of different ages, ethnicities, and backgrounds, but devoted to a common faith which is proven during adversity. Their stories are masterfully interwoven, well-illustrated and documented, and enhanced with the author's personal reflections. The pervasive theme uniting these heroes is their life testimony of sacrificial love and protection of life as represented by, "the least, the lost, the broken, and the forsaken."
So, what this book provides is not only historically accurate information but also inspirational examples of how God ministers His love through His people in the worst of times and hardest of situations. It is an appropriate blessing that those currently embattled to protect the lives of the unborn are included in this recognition of heroism.
If you are looking to inspire your family to protect those whom the Lord calls on us to protect, then, I certainly recommend *Speak Up For Life*.

Bill Davenport; Executive Director – The Valley Care Pregnancy Centre, Kentville, NS, Canada

The value of human life as made in the image of God is being undermined in today's secular society. Sheryl's book, *Speak Up For Life* highlights the Holocaust, abortion, eugenics, euthanasia, slavery, First Nations and in light of God's love, she asks the piercing question, "What can we do but speak up and act for life?" These reflections will help to disturb your quiet, motivate your heart and inspire action in your life.

Chantel Carriere - Homeschooled 3 of 6 children, Ottawa Valley, Ontario, Canada

What a beautiful, insightful, knowledgeable book, with supportive references and relevant pictures. The paintings were beautifully coordinated with the topics. I highly recommend this book for homeschooling, or even regular schooling. It encompasses various levels of learning for various ages and depths of learning. This book helps you teach your kids how humanity suffering from places around the world ties us together throughout history, with true accounts of lives lived, while opening the door to in-depth learning. When one suffers, we all suffer.

Justin Kron, The Kesher Project

Sheryl's heart and commitment to equip today's generation of Christian students is beautifully captured and presented in this much-needed resource that defends the miracle and value of human life. This book is a must-read for any student who wants to stand up for the marginalized and dehumanized in our world. Don't miss it!

Eliana Tremblay, 14 years old, Homeschool student

I really enjoyed this book. It was a pleasure to read it. I learned more about World War II and people like: Corrie ten Boom and Anne Frank, etc. I also

learned more about how slavery ended in the U.S. and how we should speak up for those who can't speak for themselves. I really liked the visuals in it. The paintings and pictures are definitely a good addition to the book. The links to videos and books were very useful when I wanted to know more about the subject. I appreciated having them. It is also a good idea to relate the content with Bible verses in each chapter and the questions helped to make us think. I highly recommend this book! Thank you Sheryl!

Acknowledgements

News Flash: Stan Elliott (pen name) is my 12 year old son. Our family enjoys reading and has recently discovered a love for history. We write stories as part of our homeschool education and because these topics are so important he willingly did some extra reading and wrote the 'News Flash!' sections found throughout this book.

Layout and Design: Some of the layout and design was done with my 8 year old son who loves buttons and trying cool new fonts and fun word art formats.

Editing: My husband read and re-read many sections of this book. He sees the details and is a good fine-tuner.

Going Deeper: I am very grateful to Michail Bantseev for editing and checking my Scripture passages and questions. He contributed the questions in the Going Deeper section. Thank you for sharing your insights and wisdom in this book.

Other Contributions: I am grateful to Janice Huse, Louise Campbell, Kenny Blacksmith and Denise Mountenay for their insights and contributions.
I am thankful to my parents who encouraged me to read when I was young, shared their faith with me, supported my travels and this book.

Art Work:
Janice Huse Artwork: www.janicehuse.com
Sheryl Ann Art: http://sherylannart.vistaprintdigital.com
email: sann101@protonmail.com
Photos:
Sheryl Ende, Landmark Scout, Kenny Blacksmith, Louise Campbell

Foreword by Bert Dorenbos
Founder of Cry for Life, The Netherlands

Willy and I have been called to pro-life ministry for our whole lives. During our time as CEO of the Evangelical Broadcasting Channel (The Netherlands), we were challenged by the film called 'The Silent Scream' produced by Dr. Bernard Nathanson. We showed the film on our national TV station. The Lord spoke to our hearts and we decided to spend the rest of our lives protecting threatened unborn lives. More than forty years ago our ministry Cry for Life was born.

Now we are retired and 80 years of age. We are alive so our calling and ministry continues. We are so thankful to the Lord for connecting us with Sheryl while she lived in the Netherlands. She was a tremendous help correcting my Dutch drafts into proper English. We are very thankful for this blessing. Back in Canada, with her husband, Sheryl started painting beautiful artwork. Now she surprised us by writing an inspiring book dealing with subjects that are close to her and to us. Her account of our joint visit to Auschwitz is very impressive. The personal stories about the Polish midwife who rescued newborn babies and the testimony of Denise Mountenay before Israeli students visiting Auschwitz are inspiring. Sheryl also included a chapter about the Underground Railroad; retelling how slaves fled to freedom in the North. It is amazing how she linked all the stories to the basic principle to be pro-life. Sheryl's creativity in adding other stories and a Dive Deeper section with more information are good. The Bible portions and questions in each chapter are very helpful for personal study and reflection.

There is reason to congratulate her in completing her manuscript. We expect to see more books from Sheryl in the near future. It is a blessing that she honours her two children in helping her to accomplish this new masterpiece of written art.

Introduction

Speak up for Life is intended to be an educational resource for anyone, of any age who loves and honours life. Through the stories of courageous people and photography from historical places, connections are made to gently introduce and understand current issues like anti-Semitism, abortion, euthanasia and marginalized people groups. The following stories unfold in order to remember the past where lives were threatened and learn from people who lived under difficult circumstances.

The Holocaust should never happen again, yet studies are finding that youth today are lacking in Holocaust awareness education. The Azrieli Foundation and Claims Conference conducted a study in 2020 in six different countries to examine Holocaust knowledge and awareness[1]. The results were startling and demonstrated gaps in Holocaust education. For example, 49% of those surveyed in Canada could not name one concentration camp out of the many that existed during WWII in Europe. In the United States, 63% did not know that six million Jews were killed in the Holocaust[2]. These results demonstrate a need for books that show eye-witness evidence of places like Auschwitz-Birkenau. *Speak up for Life* seeks to meet this need through stories, photography, and by providing additional resources.

Speak up for life is written for youth who need to know their past and understand current life issues. It could be used as a complete unit study in a school or home education curriculum. The nature of some topics covered in this book encourages parents to read with their children, especially if they are younger. Each chapter ends with a Dive Deeper section where the reader can learn more about a particular life issue, event or person through exploring the links and resources provided. Scripture and study questions encourage readers to examine topics personally and take action. This section could also be used for youth and adult small group Bible studies.

All of the pictures, unless indicated otherwise, were taken by the author. Most of the places were visited by her personally over the course of 10 years. The only place she did not visit was T4 in Berlin but this is included because of its relationship to the rest of the stories. The connections made in this book are partly from an ongoing love and interest in the Jewish people and their history, as well as involvement with a pro-life organization in The Netherlands. While living there, Sheryl had the privilege of working with Bert and Willy Dorenbos from Cry for Life (Schreeuw om Leven). Her visits to Westerbork and Auschwitz were part of a *Prayer Train* International Pro-life Conference led by the Dorenbos'.

Finally, some of the issues, like euthanasia and residential schools are presented from a Canadian perspective. If you are not from Canada please consider praying for Canada. Then find details about these and other issues presented in this book that relate to your home country.

It is a hope and prayer that this book would open the eyes of youth today to see how our Father in heaven is faithful to His people and how much He loves and honours life.

Resources:

1. "New Survey by the Azrieli Foundation and Claims Conference Finds Critical Gaps in Holocaust Knowledge", Claims Conference, accessed January 2023
 https://www.claimscon.org/study-canada/

2. "Survey finds 'shocking' lack of Holocaust knowledge among Millennials and Gen Z", NBC News, accessed January 2023
 https://www.nbcnews.com/news/world/survey-finds-shocking-lack-holocaust-knowledge-among-millennials-gen-z-n1240031

Part 1:

Focus on Israel and the Holocaust

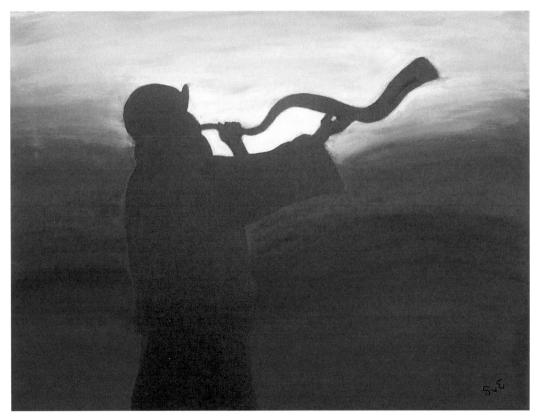

"Trumpets" by Sheryl Ann Art

Chapter 1
UNFORGETTABLE PLACES AND A PEOPLE TO REMEMBER

The past continually teaches us today through the remnants of special places and the lives of unforgettable people. Ecclesiastes 1:9 (NIV) says: "What has been will be again, what has been done will be done again; there is nothing new under the sun." This verse makes it clear that learning from history would give insight and wisdom for us today. For the past 25 years I have been learning about Israel and the Jewish people through books and traveling. This interest has brought me to many unexpected places, such as the Netherlands, Israel and Poland. Visiting these places and learning their stories allowed me to experience the reality of God's miracles and love for His people. Along the way, I discovered how connected these places and people are with life issues, such as abortion and euthanasia. Here are some of the stories with pictures that come from some of these unforgettable places and people that we need to remember and learn from in order to live wisely today.

There is a battle raging that began in the Garden of Eden where we chose to believe a lie from a serpent - the father of lies, rather than keep the one instruction our Father lovingly gave us. The Garden provided everything for Adam and Eve. God's instruction was to not eat from the Tree of the Knowledge of Good and Evil. Later, the serpent enticed Eve through half-truths and she ate the fruit and shared it with Adam. Out of this account in Genesis 2 and 3 came the grace-filled, first promise of a redeeming Messiah.

Genesis 3:15 "And I will put enmity between thee and the woman, and between thy seed and her seed; it shall bruise thy head, and thou shall bruise his heel."

Centuries after the fall in Eden the focus of this coming Messiah narrows and comes to life in the Covenant made by our Creator with Abraham and his descendants.

> **Genesis 12:2,3 "And I will make of thee a great nation, and I will bless thee, and make thy name great, and thou shalt be a blessing. I will bless them that bless thee, and curse them that curse thee, and in thee all families of the earth shall be blessed."**

The following song by Aaron Shust beautifully compiles Scriptures to show how far this blessing has reached. 'Zion' (song) by Aaron Shust
https://www.youtube.com/watch?v=E_GsKLJcum8 [1]

As grafted-in believers in the Jewish Messiah, we have joined the battle that was won on the cross and through Jesus' resurrection. The battle rages on today as we expectantly wait for His coming and the restoration of all things. Each person and place in the following chapters demonstrates a dynamic found in John 10:10. The destruction is evident and like light piercing through the stormy, dark clouds God breathes His everlasting, loving Life into those who trust in Him.

> **John 10:10 "The thief comes not, but for to steal, and to kill, and to destroy; I am come that they might have life, and that they might have it more abundantly."**

Photo: View from the dikes in Friesland, (by Sheryl Ende)

Over the centuries God's people have suffered tragedies and experienced many miracles. Our world is changing so quickly and it is best to learn from the past so we can walk close as His people and be ready for what is to come in the future. Looking into some of the atrocities that have happened to God's people and how easily life can be threatened and attacked in recent history can teach us how to live wisely in these uncertain times. More than ever we desperately need to learn His Word, pray with His Spirit in truth, and watch as we walk close to Him.

Isaiah 43:1 "But now thus says the Lord that created thee, O Jacob, and he that formed thee, O Israel, Fear not; for I have redeemed thee, I have called thee by thy name; thou art mine."

Dive Deeper!

Resources and Links

1. "Zion", Aaron Shust, accessed January 2022
 https://www.youtube.com/watch?v=E_GsKLJcum8
2. "Chosen People Ministries", accessed January 2022
 www.chosenpeople.ca
3. "Kesher Forum", accessed January 2022
 www.kesherproject.com
4. "Hope in the Holy Land", accessed January 2022
 www.hopeintheholyland.com
5. "Voice for Israel Ministries", accessed January 2023
 https://www.voiceforisrael.net

Scripture and Questions

Genesis 3:15
Isaiah 43:1
John10:10

1. What do these verses show us about the battle for life?

2. As believers, what comfort can we find in these verses?

3. Do you see other examples in the Bible where life is being attacked? Where is life being preserved?

Going Deeper

1. Read Leviticus 26:40-45, Psalms 105:4-11, and Luke 1:68-80. What do these passage tell us about the character of the God of Abraham, Isaac, and Jacob?

Chapter 2

THE HIDING PLACE

Do you like to be blessed? God tells us in His Word that we can be blessed by blessing the Jewish people and by praying for the peace of Jerusalem.

Genesis 12:2, 3 "And I will make of thee a great nation, and I will bless thee, and make thy name great, and thou shalt be a blessing: And I will bless them that bless thee, and curse him that curseth thee and in thee shall all families of the earth be blessed."

Psalm 122 (vs 6-9) "Pray for the peace of Jerusalem, they shall prosper that love thee. Peace be within thy walls, and prosperity within thy palaces. For my brethren and companions' sakes, I will now say, Peace be within thee. Because of the house of the Lord our God I will seek thy good."

Willem ten Boom started a very unorthodox prayer group in his home in 1844[1]. After an inspiring message from his minister he gathered a group to pray for the Jewish people to return to their ancestral land. He also prayed for the peace of Jerusalem which at that time was a divided city. He likely understood the significance of the above verses and the call to pray for God's chosen people. He taught his children, Casper being one of them, to pray. For three generations this clock maker and his children prayed for the Jewish people. Little did he know in 1844 that 100 years later his son (Casper) and two granddaughters (Corrie and Betsy) would be hiding Jewish people and suffer for their acts of kindness and bravery. When your family prays for God's chosen people for a

hundred years, from 1844 with Opa ten Boom to 1944 when the ten Booms were arrested, you come to love them because they are the apple of His eye.

Deuteronomy 32:10 "He found him in a desert land, and in the waste howling wilderness; he led him about, he instructed him, he kept him as the apple of his eye."

In 1940 the Nazis took over the Netherlands. The yellow star soon appeared on the arms of those who were Jewish. By 1942 Jewish families lost their work, their homes, and they were taken away to internment and concentration camps.

• •

NEWS FLASH!!!
NUREMBERG LAWS AND THE YELLOW STAR
By Stan Elliott

The Nuremberg Laws were written in 1935. The Nazi leaders in Germany decided if they want to spread their idea of a superior Aryan race, they needed to make some laws. The laws defined who the Jewish people were and denied them of their jobs, property, and citizenship. The yellow Star of David was to be a band worn on their forearm for easy identification. The Nuremberg laws were named after the city in which they were written. Many Jewish people left Germany, but for others it was not possible. They were forced into ghettos, and later sent to concentration camps. The Nuremberg laws was one of the first movements by the Nazis in an attempt to exterminate the Jews.

Sources: "Holocaust", *World Book Encyclopaedia*
Anne Frank, DK Life Stories by Stephen Drensky

• •

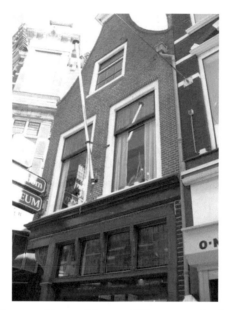

Figure 2.1: The ten Boom House (Photo used with permission)

Today you can take the train to Haarlem and walk as the ten Booms did to their clock shop and home (Figure 2.1). The street level clock shop is still active today. Turning off the cobblestone street down a narrow alley we find the main door to the ten Boom home. The kitchen is set up as it was in the 1940s and is also the welcome centre for the ten Boom museum today. Up a narrow flight of stairs, visitors quietly and reverently find a chair to sit and hear the true tales of the ten Boom family. This family was a quiet, hard-working family that followed the Lord and His Word and stood bravely in the face of Nazi tyranny. As the true tales unfold, the furniture rests in the room as meticulously preserved artifacts with no photography allowed. The beloved piano that entertained the ten Boom family and their visitors for generations stands as a reminder of the power of music. Music entertained and soothed the fear and anxiety of those who dwelled in or passed through the ten Boom home. After hearing the true

historical accounts, visitors walk up another flight of narrow, steep stairs to Corrie's room. This small room, the size of some walk-in closets today, held Corrie's bed where she lay ill as the Gestapo (Nazi police) stormed through with accusations and arrests. The linen closet at the end of the narrow room tucked away precious lives behind a false brick wall.

● ●

NEWS FLASH!!!
RESISTANCE!
By Stan Elliott

The resistance movement during WWII consisted of groups of people in Nazi-occupied countries who did things that were not permitted. This included making false papers and food coupons, sabotage, hiding Jewish people and other people. These activities were dangerous, and many risked their lives to help others.

Source: *Brave Deeds* by Ann Alma

● ●

During the Nazi occupation of the Netherlands, there arose a strong resistance movement and Corrie and her family became involved. This network of people helped Jewish people hide from the Nazis, with the goal to get them safely out of the country. The ten Boom family had a 'fake' brick wall built in Corrie's bedroom on the third floor. They often had three or four Jewish people hiding in their home. The Jewish people who stayed with them for a time would run practice drills to get to the 'Hiding Place' as quickly as possible. There was a button on the ground floor in the clock shop and in the kitchen that someone could buzz if there was danger. When the buzz was heard upstairs, everyone moved quickly!

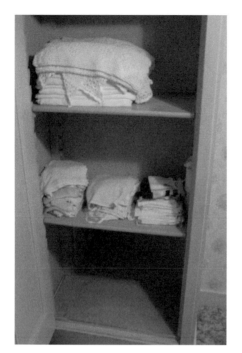 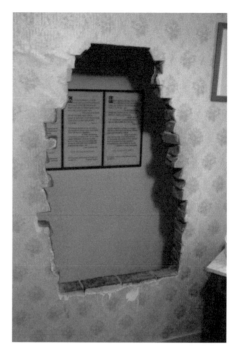

Figure 2.2: The Hiding place (Photo by Sheryl Ende)

The left side picture of Figure 2.2 shows the entrance to the hiding place that is found at the bottom of a small linen closet shelf. The right side picture of Figure 2.2 shows the wall opened up after the war to display to visitors how small the space was in this safe hiding place. A close up of the only entrance to the hiding place during the 1940s at the bottom of the linen closet is seen in Figure 2.3.

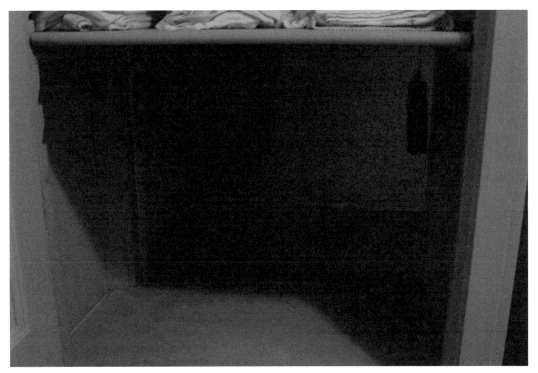

Figure 2.3: The entrance to the hiding place (Photo by Sheryl Ende)

One day the buzz echoed through the ten Boom's home, and it was not a drill; they had been betrayed. That day, six Jewish and resistance people stayed safe, while Corrie, Betsy and their father Casper were taken to prison. Those hidden people were never discovered by the Nazis, and with the help of resistance police officers they were brought to safety. Corrie received a package from her sister while in prison and under the stamp was a note that said: "All the watches in your cabinet are safe". Amazing! However, Corrie's father was in his eighties and died in prison. Corrie and Betsy were sent to Vught, a remote camp in the south of the Netherlands. Later they were moved

to Ravensbruck in Germany, where Betsy died of pneumonia. After a time in the camp, Corrie was told to leave out the front door a week before everyone her age was gassed to death.

Corrie wrote *The Hiding Place*[2] which gives her personal account of those years. She tells of the fleas that kept the prison guards away so they could have Bible studies in Ravensbruck. It tells of her walking past guards with a Bible hung around her neck that no guard saw or took so later they could have those flea-bitten Bible studies. After the war, Corrie ten Boom travelled to many countries and shared her story and wrote many books about God's faithfulness.

• •

NEWS FLASH!!!
DENMARK SAVES THE JEWISH PEOPLE!
By Stan Elliott

The Danish people all worked together to help their fellow Jewish citizens. The Nazis invaded Denmark in 1940. Danish Jews in Denmark were not persecuted until 1943, and that is when the rescue effort started. The Jewish population at that time was about 8000 people. Nearly the entire Jewish population escaped in boats across the Sound to neutral Sweden. Also, later in 1945, the Danish and the Swedish people brought together thousands of white buses to liberate concentration camp prisoners. The Danish people went to great lengths to help the Jewish people.

Source: *Darkness over Denmark* by Ellen Levine

• •

THAT WAS THEN...
...THIS IS TODAY.

Anti-Semitism means to be hostile or to discriminate against the Jewish people. Anti-Semitism may be a new term that was coined in the 19th Century, but open and deliberate hostility toward the Jewish people started over 3500 years ago, with Pharaoh giving the command to kill all Israelite boys, as recorded in the book of Exodus. Today, anti-Semitism is on the rise again in the 21st Century. Around the world there are many instances of violence toward Jewish people. In California, a small congregation has been attacked a number of times over the past five years with purposeful burning and flooding of their building. In 2020, their sign that says 'Peace to Israel' was vandalized and changed to 'Death to Israel' (Figure 2.4).

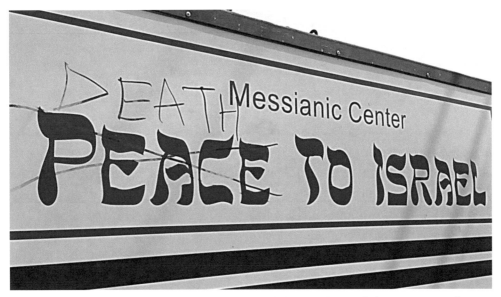

Figure 2.4: Photo: permission granted by Leaders of the congregation

In October 2021, posters were placed on the large Menorah in front of the synagogue of this California congregation, stating 'Hitler was right' (Figure 2.5). These posters were found in other places in their community.

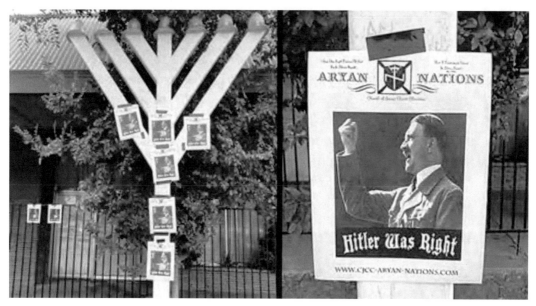

Figure 2.5: Photo: permission granted by Leaders of the congregation

These are just a couple of examples of the hateful acts that occur against the Jewish people today. Could anything good come from these acts of violence? There is a group called "Philos Action League"[8], which is a community of Christians who will stand in solidarity with the Jewish community when anti-Semitic acts occur. Justin Kron from The Kesher Project recently brought white roses to an anti-Semitic act of violence in his community. The white roses remember a Nazi resistance group called the White Rose that started in the 1940s in Germany. The White Rose members first consisted of university students, who were intent on educating their peers on the problems with Nazism.

They stood up against hatred and tyranny in their day. The Philos Action League acts in a similar way today by standing in solidarity with the Jewish community as a response to violent acts.

The congregation in California was surprised and encouraged when people in their community and beyond showered them with cards and blessings from children and adults alike - people willing to stand with them and support them. They have also seen their small congregation grow as they share the good news of Yeshua (Jesus) their Messiah within a very Jewish community. God lovingly brings His light and peace in the midst of fear and darkness.

Dive Deeper!

Resources and Links

1. "The History of the ten Boom Family, Corrie ten Boom museum, accessed January 2022
 https://www.corrietenboom.com/en/family-ten-boom
2. ten Boom, Corrie. *The Hiding Place.* Random House, 1982
3. "The Hiding Place", Redeem TV, accessed March 2022
 https://watch.redeemtv.com/videos/hiding-place-rtv-preroll
4. "Agent of Grace", Redeem TV, accessed March 2022
 https://watch.redeemtv.com/bonhoeffer-agent-of-grace
5. Drensky, Stephen. *Anne Frank DK Life Stories.* DK Children, 2019
6. Levine, Ellen. *Darkness over Denmark.* Holiday House, 2000
7. Alma, Ann. *Brave Deeds, How One Family Saved Many People from the Nazis.* Groundwood Books, 2008
8. "Philos Action League", accessed June 2022
 www.philosproject.org/action

Scripture and Questions

Genesis 12:3
Psalm 122:6
Romans 9-11 (Key verses: Romans 10:1 and Romans 11:11)

1. What do these passages tell us about our relationship with Israel?

2. Should we join Opa ten Boom and pray daily for the Jewish people and Israel? Why or Why not?

3. As a family, individual or group, do you know a Jewish family or ministry you can connect with and support?

Going Deeper

1. What is the hopeful message for Israel in Psalm 121:1-8, Isaiah 40:1-5, and Jeremiah 30:10-20, as well as for the Gentiles (the nations) who love Israel in Jeremiah 31:10-14, regarding healing and restoration for Israel from tragic historical events, such as the holocaust?

2. How do we seek for the consolation of Israel as Simeon did in Luke 2:25? How do New Testament passages like Mathew 5:4 and 2 Corinthians 1:3-7 help us relate to Israel's sufferings and to offer our comfort to the Jewish people even in a small and tangible way?

Chapter 3
WESTERBORK INTERNMENT CAMP

The remains of Westerbork[1] internment camp can be found in the northern province of Friesland in the Netherlands. The large grounds are tucked away in the fields near the two small towns of Hooghalen and Assen. The camp was founded in 1939 as a refugee camp for fleeing Jewish people after Kristalnacht[2]. The 'Night of Broken Glass' (Kristalnacht) occurred in 1938 from November 9 to 10. Nazis in Germany burned and vandalized Jewish synagogues, homes and businesses. One hundred Jews were killed that night while 30,000 men were sent to concentration camps. Some Jewish people fled to other countries like the Netherlands. By April 1940, there were 750 Jewish refugees living in Westerbork, including some from the infamous St. Louis Ship.[3] In 1942, Nazis turned the refugee camp into a detainment camp for Jewish people on their way to concentration camps in Germany and Poland.

When the Nazis took over the Netherlands, they forced Jewish people out of society just as they did in Germany. At first the Jews were to wear the Star of David for easy identification. Soon their jobs, homes and lives were taken from them. They were sent to camps like Westerbork in the north and Vught[3] in the south. Vught is another camp that is tucked away in the fields and forests of this small country. Many of the Dutch resisted and helped hide Jewish people in homes and in the country throughout the war. Examples like the ten Booms and Anne Frank show the strength of the Dutch resistance. There was always danger and betrayal but some lives were saved.

When Bert Dorenbos from Schreeuw om Leven (Cry for Life, a pro-life ministry in the Netherlands) was a preschooler, he remembers standing with his Mom and watching the trains go by every Tuesday at 1pm[4]. They would see the trains leave Westerbork full of people but two days later they returned

empty. In this way 90,000 Jewish people received a one-way ticket to Auschwitz concentration camp. Today, there still exists film footage recorded in the 1940s at Westerbork that show families with luggage coming off the train when they arrive at Westerbork and going back on later for the cramped and deadly ride to Auschwitz. The film shows people sitting and registering their names, birth dates, and where they were from, as if they were moving to another location. However, they never returned. Anne Frank was aboard the last train that left Westerbork; soon after, the Netherlands was liberated. The trains finally stopped.

NEWS FLASH!!!
ANNE FRANK!
By Stan Elliott

Anne Frank was born on June 12, 1929. Her family was Jewish. She moved with her family from Germany to Amsterdam in 1933. On July 5 1942, she went into hiding for the next two years. Her family was caught by the Nazis and taken to Westerbork where she boarded the last train to Auschwitz concentration camp. She was later moved to Bergen-Belsen where she died of typhus. Her father is the only one who survived and later published the diary that Anne wrote while in hiding.

Source: *Anne Frank DK Life Stories* by Stephen Drensky

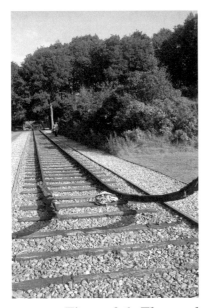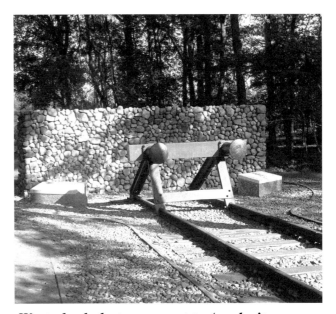

Figure 3.1: The tracks at Westerbork that once went to Auschwitz
(Photos by Sheryl Ende)

From 1942-1945, every Tuesday at 1 pm, train cars at Westerbork were filled to the brim with precious human cargo on a one-way, 24 hour trip to Auschwitz and other camps in Europe. The train tracks at Westerbork (Figure 3.1) have been pulled up; never again are they to bear the weight of trains or condemned human cargo. The bent train tracks bear witness of what happened, declaring that such torment should not occur again.

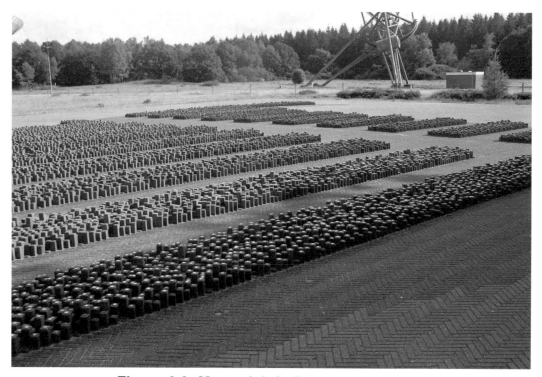

Figure 3.2: Memorial dedicated to the lives
that went through Westerbork
(Photo by Sheryl Ende)

A memorial at Westerbork (Figure 3.2) was set up in 1992 to remember each and every life that left this internment camp. The bricks represent 102,000 lives that passed through Westerbork on the trains.

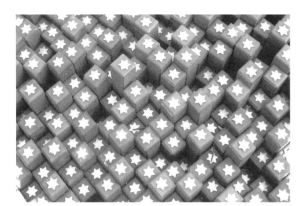 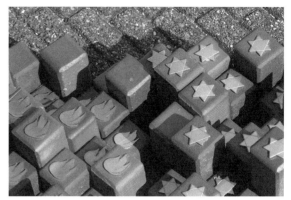

Figure 3.3: Close up view of the blocks (Photos by Sheryl Ende)

The Star of David (Figure 3.3) represents the 90,000 Jewish lives; the flame represents Roma and Sinti people who lived in caravans and were banned from moving around by the Nazis. The blank stones represent the Dutch resistance fighters.

Westerbork is a place that started out with good intent: to help fleeing, persecuted Jewish people. It is incredible how quickly the tables turned in two short years (1940-1942). Today, Westerbork exists as a memorial to future generations to protect life.

Dive Deeper!

Resources and Links

1. "Westerbork Concentration Camp", accessed January 2022
 https://encyclopedia.ushmm.org/content/en/article/westerbork
2. "Kristalnacht" Holocaust Encyclopedia, accessed November 2022
 https://encyclopedia.ushmm.org/content/en/article/kristallnacht

3. "Voyage of the St. Louis", Holocaust Encyclopedia, accessed November 2022
 https://encyclopedia.ushmm.org/content/en/article/voyage-of-the-st-louis
4. "Camp Vught", accessed November 2022
 https://www.jewishvirtuallibrary.org/vught-concentration-camp
5. "The Train", Kies dan het Leven, accessed November 2022
 https://kiesdanhetleven.nl/media/clip/446836293/ *PLEASE NOTE: The first 15 minutes are focused on Westerbork. The last 15 minutes connect the Holocaust with abortion.* **It includes graphic pictures.**
6. "Holocaust in the Netherlands", accessed November 2022
 https://en.wikipedia.org/wiki/The_Holocaust_in_the_Netherlands
7. Eman, Diet. *Things we Couldn't Say,* W.B Eerdmans, 1999

Scripture and Questions

Genesis 3
Genesis 37 and 39
Proverbs 24:10-12
Micah 6:8

1. Can you think of any passages in the Bible where a safe place or something good was flipped to something evil or wrong? Also consider where something evil turned out for good. How can we find guidance or comfort in these passages?

2. What active or passive role would you hope to play in a land where such injustice is occurring? (Consider Bert Dorenbos's mother and the ten Boom family.)

3. How do the above passages from Proverbs and Micah challenge us to live when others are being persecuted?

Going Deeper

1. Isaiah 49:13-26 looks prophetically into the future restoration of Israel. What does the Almighty have to say about those who oppressed, afflicted and exiled His people? How will the tables be turned on those who harmed Israel?

2. According to Joel 3:1-8 and Matthew 25:31-46, how will Yeshua (Jesus) the Messiah, at His second coming repay those who harmed "the least of these my brothers" (Matthew 25:40)? How will He reward those who have helped His people?

Chapter 4
AUSCHWITZ-BIRKENAU CONCENTRATION CAMP

Standing at the entrance to the Auschwitz concentration camp, the evil and hatred are still tangible; it is almost too evil to cry. The tears held back and could not fall as the evidence of the attack on life is so pervasive on these massive grounds.

• •

NEWS FLASH!!!
HOLOCAUST
By: Stan Elliott

The Holocaust was the Nazi's 'final solution', involving the systematic massacre of around 6 million Jewish people. It began when Nazi Germany stopped buying Jewish products after the Nuremberg laws were established, and escalated to tens of thousands of Jews dying in work and concentration camps. Gas chamber camps, notably Auschwitz, took the most lives of prisoners.

According to the Oxford Dictionary the word Holocaust means: large scale destruction, especially by fire. The Holocaust was a terrible time in history and should never be repeated.

International Holocaust Remembrance Day

In 1945 Auschwitz-Birkenau was liberated on January 27! The United Nations designated this day as International Holocaust Remembrance Day to honour the six million Jewish people who perished during the Holocaust.

Source: *Signs of Survival; A memoir of the Holocaust*
by Renee Hartman with Joshua M. Greene[1]

• •

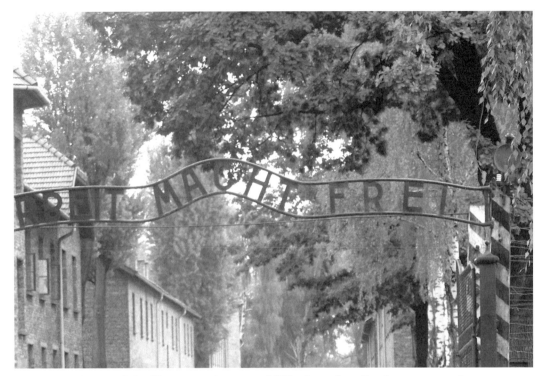

Figure 4.1: Close up picture of 'Work makes free' entrance sign
(Photo by Sheryl Ende)

The entrance sign in Figure 4.1 looks welcoming with words that say "Work Makes (you) Free". However, it is soon evident that the opposite was occurring on a brutal, inhumane and massive scale. There was no freedom here. "Work Makes (you) Free" proclaimed a lie under which the people who were brought to Auschwitz against their will, were forced to live. Prisoners were mostly Jewish, but also Christian, gypsy, political prisoners, and others. During its five year operation (1940-1945) 1,100,000 people died in the Auschwitz

camp. The majority, about 1,000,000, were Jewish[2]. There was no freedom found here, but only suffering and destruction.

The solid brick buildings in Auschwitz were well-made, large, buildings with many people packed in them (Figure 4.2). Some of these buildings now house collections that were kept from the prisoners and guards after liberation. For example, there are glass containers – large ones that contain hair shaved from the prisoners. There is a collection of shoes from the prisoners, 3800 suitcases with names and addresses, 12,000 kitchen utensils and more. These museum artifacts are important as a witness to what occurred in Auschwitz.

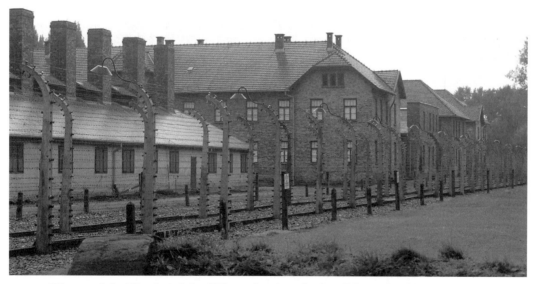

Figure 4.2: The brick buildings in Auschwitz (Photo by Sheryl Ende)

'Prisoners' attempting to leave Auschwitz did not have an easy task. Watchtowers, barbed wire fences, and guns kept the people inside; freedom evaded them (Figure 4.3).

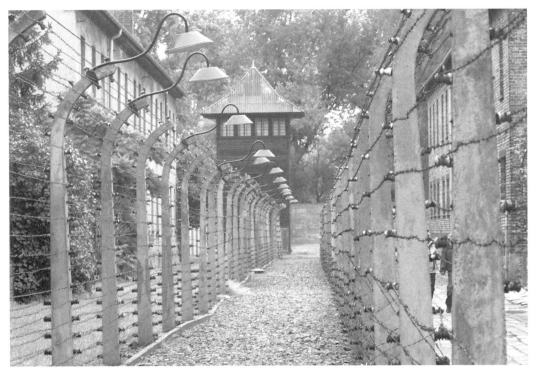

Figure 4.3: The fences and towers around Auschwitz (Photo by Sheryl Ende)

The death wall seen in Figure 4.4 was reconstructed after the war as a memorial. This death wall was where several thousand people, mostly political prisoners, were shot. It was taken down in 1944 while the camp was still operating.

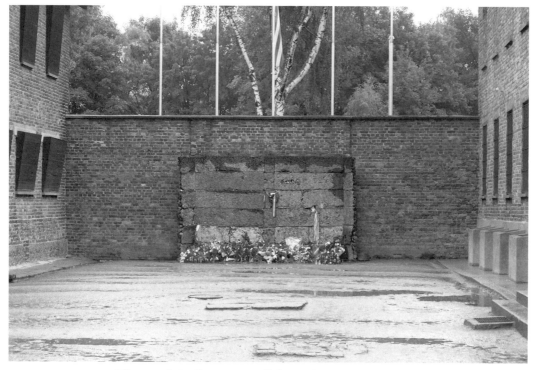

***Figure 4.4: Cement wall for a firing squad, now
a memorial (Photo by Sheryl Ende)***

Birkenau's entrance gates stand a short, five-minute drive down the road from the grounds of Auschwitz (Figure 4.5). Birkenau was another massive compound that housed humanity in unliveable conditions, forced to work or die.

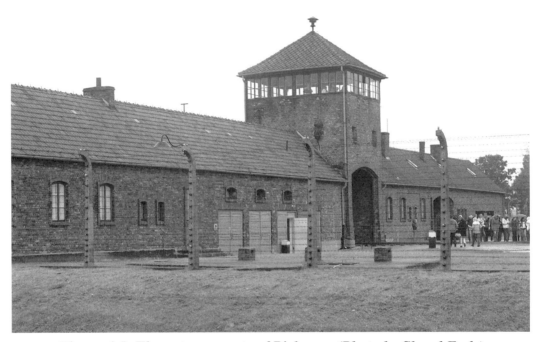

Figure 4.5: The entrance gate of Birkenau (Photo by Sheryl Ende)

The security at Birkenau was as tight as at Auschwitz, with many towers and high barbed wire fences. Standing at the top of the Birkenau entrance tower provides a panoramic view of the grounds. Large fields on either side hold some of the buildings that still stand as sentry witnesses to their long passed hostages (Figure 4.6). There is also unmistakeable evidence of row upon row of destroyed dwellings. As Allied forces came closer near the end of the war, the Nazis did their best to remove evidence by destroying buildings.

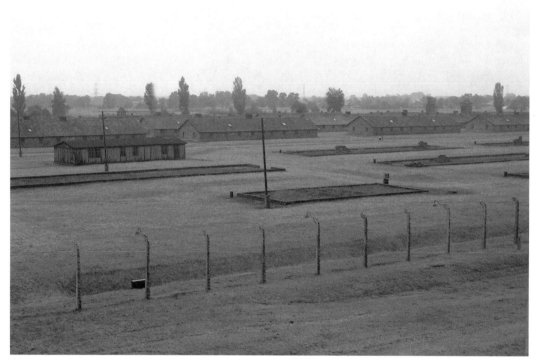

Figure 4.6: View from the entrance tower of Birkenau's grounds
(Photo by Sheryl Ende)

Down on the ground looking back at the entrance from inside the camp, the train track ends (Figure 4.7). The trains came from Westerbork and other cities and camps around Europe. All those trains with precious human cargo ended here, and so did many lives.

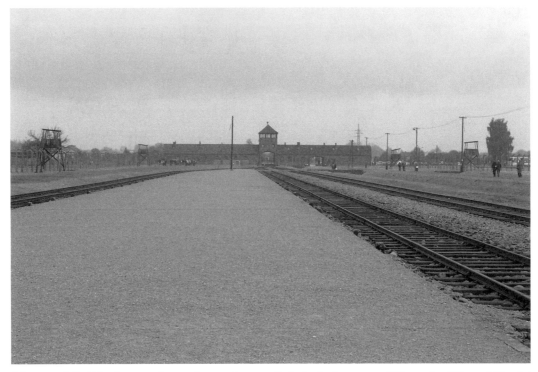

Figure 4.7: Platform where the trains ended their journey (Photo by Sheryl Ende)

Beside these train tracks, the division of families occurred. Some went immediately to the gas chambers: the elderly, the weak, and the infirm. Others went to the barracks to endure forced labour. Anne Frank and her sister were separated from their father beside these tracks.

The chimney from the incinerator in Figure 4.8 testifies to the great loss of life. This incinerator still stands on the Auschwitz grounds which experienced little change since the 1940s. The brick buildings here did not get bombed as the Allied forces came with the flame of liberation. Much of the destruction seen today on the Birkenau grounds was done by the Nazis themselves in an attempt to hide what was going on as the war ended.

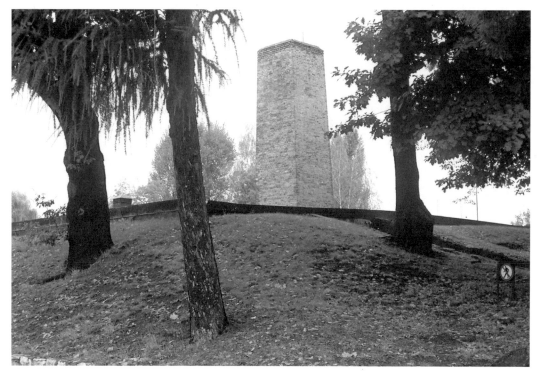

Figure 4.8: The chimney from the incinerator (Photo by Sheryl Ende)

The gas chambers for "unwanted" women, children, the elderly and others were bombed by the Nazis before the end of the war as well. Figure 4.9 shows where many walked down to have a 'shower.' Later we will learn where this weapon was first formulated in Berlin.

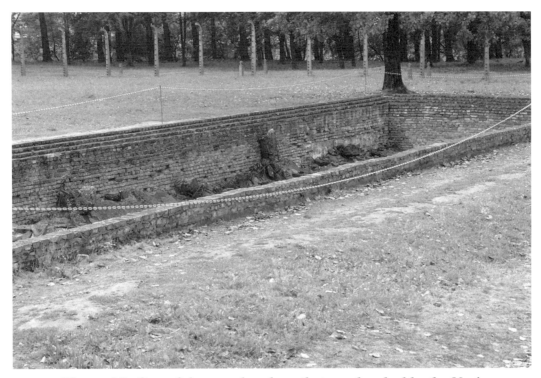

Figure 4.9: One of the gas chambers that was bombed by the Nazis
(Photo by Sheryl Ende)

The difference between the buildings at Auschwitz and Birkenau are stark (Figure 4.10). The wooden buildings at Birkenau had no protection from the elements. Cattle would have had a hard time living well, and keeping warm in these windblown buildings.

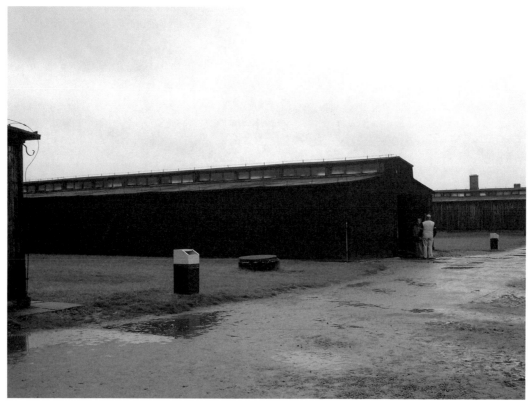

Figure 4.10: Wooden buildings at Birkenau (Photo by Sheryl Ende)

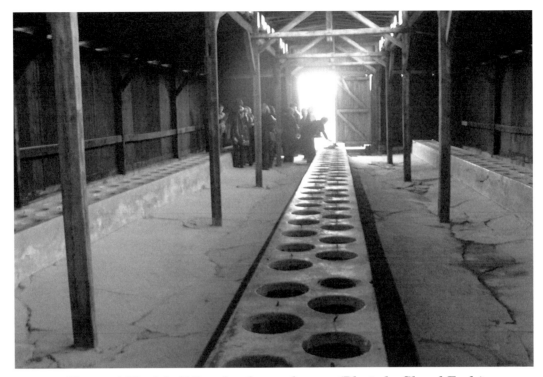

Figure 4.11: A building for the washroom (Photo by Sheryl Ende)

Figure 4.11 shows one of the barracks that existed as the bathroom. The holes are toilets that people were allowed to use only once or twice a day at a certain time. There were usually more people than places to sit.

In the long, boarded buildings many lives were packed on bunks that were three levels high (Figure 4.12). Some beds had to be shared by two people. Most 'prisoners' suffered from health disorders and diseases.

Can anything good be found in such a desperate place? The following are two miraculous and healing stories that came out of this place of pain.

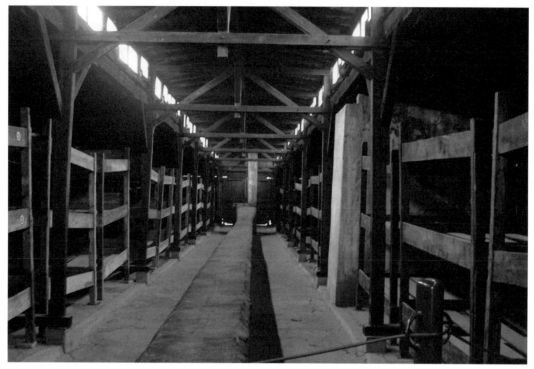

Figure 4.12: A building for sleeping quarters (Photo by Sheryl Ende)

The Midwife of Auschwitz

The first story is from a document called the Midwife of Auschwitz[3]. Stanislawa Leszczynska was a midwife who lived with her family in Poland. As a devout Catholic family, they were very involved with the resistance movement in Nazi occupied Poland. After years of working discretely, they were discovered and she was sent to Auschwitz. She had a deep faith and walked in the ways of the Lord and lived like Puah and Shiphrah in Exodus 1:15-21. During her two years at Auschwitz, Leszczynska ignored every order to kill a Jewish baby at

birth. She managed to deliver 3000 healthy babies during her time in Auschwitz in the midst of the most destitute and deplorable conditions imaginable. She did not lose one mother or child in those two years. She delivered three or four babies a day. Doctors in Berlin could not comprehend how she did not lose a single mother or baby when even in the best hospitals in Germany a mother or child can die from numerous complications. Many babies did not survive long after birth because of the deplorable conditions, but others who were born near the end of the war still live on today in their grandchildren. Our Father in Heaven loves life and honours those who protect life!

Denise Mountenay and Forgiveness

Here is one more healing story that was written in part with Denise Mountenay, from Canada[4]. In 2008 an international delegation of pro-life leaders gathered at Westerbork to pray, and then took a train from Amsterdam in the Netherlands to Auschwitz in Poland to pray for life. This group was led by Bert and Willy Dorenbos and organized by Schreeuw om Leven (Cry for Life). After a time of worship and prayer on the Birkenau grounds was complete, Denise saw a group of Israeli high school students (some had Israeli flags wrapped around them) walking through the former Auschwitz-Birkenau concentration camp. Denise was compelled to approach their teacher and shared that her father was German and that she would like to apologize to the Israeli students and people on behalf of her German heritage. The teacher quickly had the students sit down, and Denise began to say how sorry she was that her father was German, and for the atrocities that took place against the Jewish people. With tears in her eyes, she asked them to forgive the German people. Subsequently, two or three female students approached Denise and put their arms around her. She then, with tears got to share with these youth how she had also done atrocities when she ignorantly had abortions.

One teenage boy shouted out, "But that's a woman's body, it's her choice."

Denise replied saying, "But, it was the German's choice to do what they did, and that was wrong. Besides, when a woman is pregnant, there is another little human body, living inside her body. And two wrongs do not make a right."

She mentioned that over 40,000 Jewish babies are killed every year in Israel by Jewish doctors. It also involves the shedding of innocent blood. She encouraged them to love life and protect the lives of babies. Many of the young women and others from the group from Israel came and hugged her. What a testimony to guard and protect all life in the midst of Auschwitz.

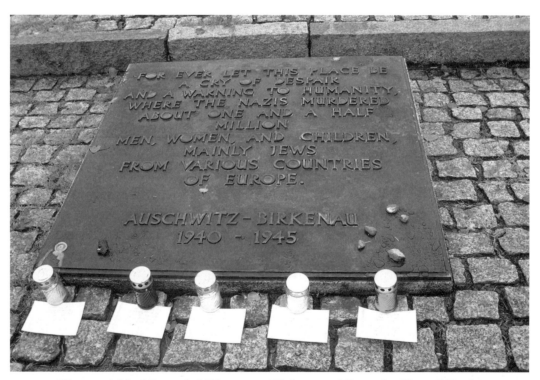

Figure 4.13: Memorial Plaque at Birkenau (Photo by Sheryl Ende)

The memorial plaque in Figure 4.13 says:
"For ever let this place be a cry of despair and a warning to humanity, where the Nazis murdered about one and a half million men, women and children, mainly Jews from various countries of Europe. Auschwitz-Birkenau 1940-1945"

THAT WAS THEN...
...THIS IS TODAY.

Bert Dorenbos and many other pro-life leaders like Denise Mountenay and Allan Parker from the Justice Foundation, see connections between the violence of the Holocaust against the Jewish people and the number of abortions that occur around the world today. The World Health Organization estimates that 73 million abortions occur each year around the world[5]. This number is growing and abortion victims far outnumber victims of any disease or virus[6]. Today, in Canada and other countries there are pregnancy centres that provide help, support and care for the mother, father and child. They also provide support for women who regret having an abortion. This approach speaks Life and there are many opportunities to join these efforts. Pregnancy centres provide a safe haven for women and men to find hope and help.

The example of the midwife of Auschwitz in the midst of such brutality is nothing short of amazing, and demonstrates the very grace of God in action. She was His hands and feet loving the moms and their little ones in the middle of the Holocaust. Today, many people are standing up and speaking for the unborn. There are abortion survivors who have been spared and live incredible lives. One miraculous story is the life of Gianna Jessen[8]. After surviving a saline abortion, the doctor who attempted to abort her was surely shocked at her live birth and had to sign her birth certificate. She declares to many people around the world today that she has the gift of Cerebral Palsy. She speaks up for the

ones that have not survived abortions. Gianna's life story, as told in her book, is an inspiration for us to speak up for life. The following Personal Reflection is another way that we can speak to those around us about how much God loves life.

• •

Personal Reflection of the Book Cover Painting 'Josiah':

A dear friend of mine expecting her fourth child was given devastating news after her first ultrasound. The doctor told her their baby had Alober Holoprosencephaly and would not live. The doctor asked when she would like to schedule the abortion. My friend and her husband grappled with this news. They knew God could heal their baby and they knew He would not want them to take their baby's life. Their decision was firm but what shock came to them when some church members told them it was understandable to choose abortion in this case.

They kept their baby and trusted God for the process, come what may. Josiah was born 2 months early. At the hospital with their three older children they spent two precious hours with little Josiah. The healing we all prayed for did not come but these faithful parents chose to fear God and honour Josiah's little life. The painting on the cover of this book is of Josiah being held in his mother's hands. It was one of the first paintings I had done with advice from Janice Huse, who you will meet later in this book. I painted while my own heart broke for the family and prayed for God to comfort them and hold their family close. The song in the link below was also written by friends to remember Josiah.

https://www.youtube.com/watch?v=UXNXIDa2iHg

• •

<u>Dive Deeper!</u>

<u>Resources and Links</u>

1. Hartman, Renee with Greene, Joshua M. *Signs of Survival; A memoir of the Holocaust.* Scholastic Nonfiction, 2022.
2. "Museum of Auschwitz", accessed June 2022
 www.auschwitz.org
3. "The Midwife of Auschwitz delivered 3,000 babies in Unfathomable Conditions", History, accessed May 2022
 https://www.history.com/news/auschwitz-midwife-stanislawa-leszczynska-saint
4. "Denise Mountenay", Keynote Pro-life Speaker, accessed April 2022
 www.denisemountenay.com
5. "Abortion", World Health Organization, accessed June 2022
 https://www.who.int/news-room/fact-sheets/detail/abortion
6. "World Health Organization World-o-meter" accessed March 2022
 https://www.worldometers.info/
7. "Gianna Jessen", Pro-life Advocate, accessed February 2002
 http://giannajessen.com
8. Renshaw, Jessica Shaver. *Gianna: Aborted and Lived to Tell about it.* Focus on the Family, 2011.
9. "How to Speak up for Life", accessed June 2022
 http://www.cwfa.org/wp-content/uploads/2014/08/How-to-Speak-Up-for-Life-eBook.pdf

Sheryl Ende

Scripture and Questions

Matthew 5:11
1 Peter 4:12-16
1 Peter 5:6-10
2 Timothy 3:10-17

1. How could the above passages help or comfort the midwife of Auschwitz?

2. How can the above passages help us prepare to live godly lives no matter what our circumstances?

3. As a family, individual or group is there a pro-life group or ministry centre in your area that you could support or help in a practical way?

Going Deeper

1. What do these Scripture passages in Isaiah 25:8, 9, Revelation 7:13-17 and Revelation 21:3-7 tells us about comfort for those in Israel who have shed many tears?

2. What is a reproach? How is our Father going to lift the reproach from His people, as He promised in Ezekiel 34:27-31, 36:15 and Zephaniah 3:16-20?

3. According to Psalm 69:7-10 and Romans 15:2, 3, whose reproach did the Messiah bear? How are we to walk in His footsteps?

Chapter 5
YAD VASHEM

Let's travel to the Land of Israel 60 years after the conclusion of World War II, and tour the Holocaust Museum in Jerusalem. For 2000 years, there was desert and swamp in this land roamed mostly by Bedouins. Yet, out of the ashes of places like Auschwitz, a nation was reborn in the Land of Israel in 1948.

Ezekiel 34:12-14 "As a shepherd seeks out his flock in the day that he is among his sheep that are scattered; so will I seek out my sheep, and will deliver them out of all places where they have been scattered in the cloudy and dark day. And I will bring them out from the people, and gather them from the countries, and will bring them to their own land, and feed them upon the mountains of Israel by the rivers, and in all the inhabited places of the country."

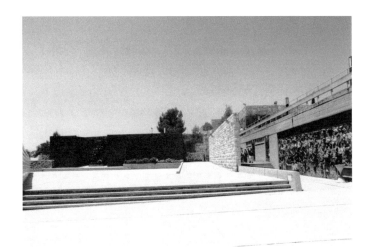

Figure 5.1: Yad Vashem entrance (Photo by Sheryl Ende)

Yad Vashem - The World Holocaust Remembrance Centre (Figure 5.1) was established in 1953[1] in Jerusalem. Today, the 45 acre grounds hold a number of museums, research and education centres as well as memorials and monuments. The Holocaust History Museum displays the history as recorded in newspapers, posters, artifacts and documents from the era of WWII. You can spend hours reading the propaganda[2] and the deception that the Nazis inflicted on the German people and the world. The lies are now evident and incomprehensible but at that time they attempted to convince a nation that Aryans were a superior race and that Jews and others were not. Social distancing was found in the Nuremberg laws and led to the Jewish people losing their jobs and homes to ghettos, forced labour, and concentration camps. The walls in the history museum include so many pictures and details that were kept about people destined for places like Auschwitz.

• •

Personal Reflection:

When I visited the history museum in Yad Vashem, it was overwhelming. I already knew so much of the details from books that I had read that I could hardly pause to read or take in all the photos. I wept as I walked through the numerous passages and hallways filled with information and pictures. Outside, near the exit is the Garden of the Righteous; here I found Corrie ten Boom's tree (Figure 5.2). I sat and found peace and hope in how the Lord works for His people.

• •

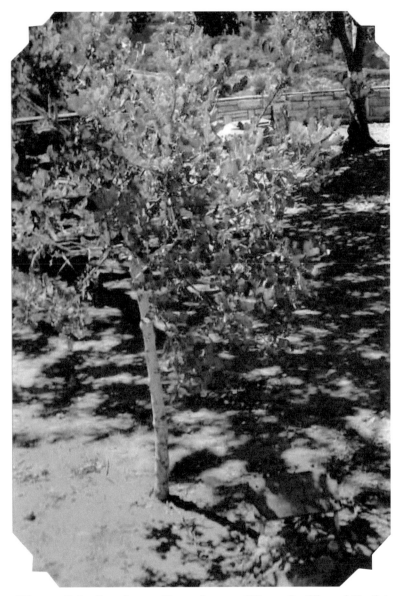

Figure 5.2: Corrie ten Boom's tree (Photo by Sheryl Ende)

Personal Reflection:
The Children's Memorial in Yad Vashem

There is a very special place in Yad Vashem found in the Children's Memorial. Here is what I wrote about the children's memorial in my photo album from 2001 after my trip to Israel with Chosen People Ministries:

"We went through the Children's Memorial that was designed by a Jewish couple from San Francisco. During WWII the couple, along with her mother and their baby son were taken from their home and put on cattle cars. At the concentration camp the grandmother of the baby was separated and the mother had given her the baby boy thinking surely he would be safer with an older woman. They both died in the gas chambers. The young couple survived the work camps and were reunited after the war. They had two daughters and she spent years going in and out of psychiatric hospitals. This couple designed the Children's Memorial. Since then she has not gone into a hospital.

"The memorial: You enter through a narrow gate into a dark room as the children would have gone through in the camps. The first room has a wall of 8 large pictures of Jewish Children's faces. As you walk through you hear the names of the 1.5 million children that were killed. The next room is even darker and as you walk through you are surrounded by 1.5 million stars, one for each child. The source of the stars are 5 burning candles that are reflected off of numerous mirrors. When you step outside you see the picture below (Figure 5.3): The Garden of the Righteous on your left and the city of Jerusalem on your right. Both signify hope, a home and a future for every Jewish child."

Figure 5.3: Trees of the Righteous and Jerusalem
(Photo by Sheryl Ende)

• •

NEWS FLASH!!!
THE GARDEN OF THE RIGHTEOUS
By Stan Elliott

The Garden of the Righteous is a garden of trees planted on the grounds of Yad Vashem Holocaust Museum in Israel. Each tree commemorates a certain person who helped a Jewish person during WWII. It is a way to honour the help and care people gave during the

Holocaust to Jewish people. The first trees were planted in 1962. By 1989 there were 2,000 trees planted. They decided to construct a wall to write the names of the Righteous that continued to be added. In 1996 there were 14,000 Righteous that had been honoured by Yad Vashem.

Source: www.yadvashem.org

Figure 5.4: The Garden of the Righteous (Photo by Sheryl Ende)

• •

NEWS FLASH!!!
PROPAGANDA
By Stan Elliott

Propaganda was used by national leaders, like the Nazis, to tell their nation that the enemy was wrong, and their side would win. In some Axis countries this created a strong sense of national pride. In Germany posters and news articles vilified the Jewish people to promote their thoughts of a superior Aryan race. Propaganda was also used to tell people on the home front in Allied countries to help with the war effort. It took on many forms such as posters, radio broadcasts and leaflets.

Source: *Eye Witness World War II* by Simon Adams

• •

THAT WAS THEN...
...THIS IS TODAY.

It takes only a short amount of time to compare media sources and find that many are funded by certain groups or governments today. The goal is to convince as many people as possible of something they have decided is true. Today social media is in our homes, in our hands, and is adding exponentially to the chaos of news that flows around us. No media source is free from bias or influences from funding sources. The best we can do is first seek our Father's wisdom, hold fast to His Word each day, and hold very lightly and loosely all the media that comes before our eyes and ears. Remember that we have control of what we put in front of us.

Psalm 119:105 "Thy Word is a lamp unto my feet and a light unto my path."

Dive Deeper!

Resources and Links

1. "Yad Vashem", accessed May 2022
 https://www.yadvashem.org/
2. "Critical Thinking Check #5: Check for Propaganda (Episode 9)",
 Answers in Genesis Canada, accessed February 2022
 https://www.youtube.com/watch?v=VhNYjrFQme8&list=
 PLW0NarHyjVwgIJQ_VRZdsj0prSAS_clMx&index=10
3. Adams, Simon. *Eyewitness World War II*, DK Children, 2021

Scripture and Questions

Ezekiel 34:12-14
Jeremiah 31 (Key verses: 3, 8, 33, 36, and 37)
Isaiah 49:8-16
1 John 4:1-6
1 Timothy 2:1-3
Jude 9

1. What is the connection between Jeremiah 31/Isaiah 49 and the rebirth of Israel in 1948? What promises have yet to be fulfilled?

2. How can we discern what is true in mainstream media? Should we even pay attention to it? What are some strategies to interact in a healthy way with media?

3. In what ways can we respect those in authority according to 1 Timothy 2:1-3?

4. What do we do when the government or other people in authority go against God's Word?

Going Deeper

1. How are the events of the Holocaust similar or different to the events described in Esther, specifically Esther 3:11-13?

Part 2:
Widening the Scope

"Reeds" by Sheryl Ann Art

WIDENING THE SCOPE:
LIFE ISSUES AND PEOPLE GROUPS

Up to this point, the focus has been on the Jewish people and the Holocaust. Israel has been God's chosen people since Abraham, with space always existing for those who would join Abraham's descendants and follow the Living God and the instructions He gave to His people through Moses. Through salvation in Jesus, we who are believers are now grafted in with His chosen people. He calls and enables us to be His hands and feet to those around us. The evidence of the Holocaust is still evident today in many places like Westerbork, Vught and Auschwitz. Currently anti-Semitism is on the rise, and as believers we have opportunity to stand and speak up to this current violence. As the midwife of Auschwitz preserved life one by one, we can be the pro-life voice today as our culture struggles with abortion. The challenge of media today is as prevalent as the propaganda that was wielded during WWII. Social media is nearly overwhelming our culture today. Tools from God's Word are essential to live and respond in love to these issues we all face today.

The focus will not shift from this, but the scope will be widened to look in more depth at the attacks on the lives of the elderly, the physically- and mentally-challenged, as well as the experiences of two special groups of people: African-Americans and the First Peoples of North America. There is an important connection here, because all these groups have been or still are seen as less than heart-beating, soulful, spirit-filled human beings. The core of this battle against life can be found in John 10:10 where it says that the thief comes to steal, to kill, and to destroy. But we will see our Father's mercy and love as Jesus comes to bring life more abundantly. Our Father loves life and brings life to those who trust in His Son our Messiah Jesus. He leads us by His indwelling Holy Spirit and calls us to watch and pray and speak up for life.

Chapter 6

T4 PROGRAM

Life is even more attacked today than it was in the days of WWII. Eugenics is a root that contributed to some of the events that occurred in the 1930s and 1940s, and its deadly fruit still exists in society today. The eugenics movement has a long history, with recent origins in the works of Darwin and Galton (1800s). One eugenics ideology branch was the belief of the Nazis in a superior Aryan race, while the Jewish people were considered inferior. This ideology became legal in the Nuremberg laws written in 1935. As mentioned before, Jewish people in Germany had their jobs and homes taken away because of these laws. Many Jewish families left Germany, but for those who stayed behind, life became very difficult - even deadly. Eugenics ideology made a level path for millions of lives to pass through the fire of the Holocaust. In the 1930s, German society for the most part accepted fearfully or passively, what was going on around them. An understanding of how eugenics contributed to the acceptance of segregation and death is essential. This allows open eyes in today's culture that still accepts death and segregation.

• •

NEWS FLASH!!!
EUGENICS
By Stan Elliott

The word 'Eugenics' is similar to the Greek word 'well born'. Modern eugenics was created by Sir Francis Galton in 1865. The notion behind it was that if you pair two smart or strong people together, their kids will be smart and strong. There are two types of eugenics: positive and negative. Positive eugenics tries to make desired genes stronger, while

negative eugenics tries to cut out traits that are not desired. Eugenics is controversial because it is linked with discrimination and injustice.
Source: "Eugenics facts for kids", https://kids.kiddle.co/Eugenics

• •

Another eugenics branch that came up in Nazi Germany in the 1930s was the treatment of people with special physical or mental abilities. Let's visit another place in Germany from the pre-WWII era to see how people who had special needs and the elderly were attacked. The tools used in this attack ultimately led to the gas chambers used in many concentration camps. In Berlin at Tiergartenstrasse 4 (T4) is where the T4 Project began and got its name. It was decided by leading medical officials and the Nazi government that elderly and handicapped people in asylums were not fit to live. This was another popular eugenics ideology of the day. These precious people were considered to be a drain on society that contributed little to nothing. The first solution used by leading doctors of that day was to give patients in institutions morphine and use starvation to be rid of them. Many died, but it was a long process that could sometimes take months. The solution to expedite the killing was to use poisonous gas made of chemicals. At first, the method doctors used entailed putting the elderly or handicapped in a bus to be gassed with chemicals (Figure 6.1). By the time the war started, showers were used in places like Auschwitz-Birkenau and the list of unacceptable people lengthened to include the Jewish people, Gypsy people, Christians or anyone who spoke up against Hitler.

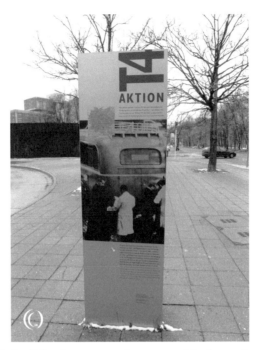

Figure 6.1: Memorial of the buses used to gas elderly and special needs people. Photo: used with permission from www.landmarkscout.com

THAT WAS THEN...
...THIS IS TODAY.

Across the board the attack on life from the cradle to the grave is evident. There is no Biblical option given to us to take our own or other's lives. However, doctor-assisted suicide is legal now in many countries. European countries like The Netherlands and Belgium are leading the way in euthanasia practice. The Netherlands legalized euthanasia in 2002. This means that a doctor can legally

assist a patient to die. Certain criteria must first be met. However, legalizing assisted dying opened a door to a slippery slope that might not know an end. In 2003, there were approximately 1600 cases of euthanasia reported in the Netherlands[5]. In 2016, that number rose to over 6000. In 2013, there were discussions in Belgium to allow minors to request euthanasia. In 2016, there were groups in the Netherlands advocating euthanasia for those who felt they had completed life. This is important to consider because once the door has been opened to choosing death, it is not an easy one to close.

> ***Isaiah 5:20-21 "Woe to those who call evil good and good evil, who put darkness for light and light for darkness, who put bitter for sweet and sweet for bitter. Woe to those who are wise in their own eyes and clever in their own sight."***

In Canada, the door to euthanasia opened in 2016. 'Medical assistance in dying' (MAID) is a request from people at the end stage of life with an incurable disease. In 2016, about 1,000 MAID deaths were reported. In 2020, over 7,500 were reported[7]. According to law, certain requirements must be adhered to before MAID can proceed. Offering palliative care is one of these requirements that must be given to a patient. Canadian Virtual Hospice defines palliative care this way: *"Palliative care supports people who are living with a life-threatening illness, condition, or health situation. It treats the whole person and their family and not just the disease, condition, or body part. Palliative care can be provided to people of any age, in any setting, by healthcare providers, family members, and other caregivers. It is provided for as long as needed – hours, days, weeks, months, or years."*[8] There are many special people – pastors, nurses and doctors who have been there for many people in the end stage of their lives and given them the comfort and care they need to die peacefully. These pastors and nurses will affirm and call for better palliative care over MAID.

Loving and coming alongside those who are dying and showing them the love and truth of Jesus is their cry.

Today, doctors often declare how many days or years are left in someone's life when they give a diagnosis. How do they know? Only our Father knows the days appointed to each and every life and as you can see He loves miracles! Every life has a purpose and is loved by God. Watch out for those you love. Keep them close and speak up for life.

Proverbs 24:10-12 "If thou faint in the day of adversity, thy strength is small. If thou forbear to deliver them that are drawn unto death, and those that are ready to be slain; if thou sayest, "Behold we knew it not", does not He that ponders the heart consider it? And He that keeps thy soul, does not He know it? And shall not He render to every man according to his works?"

Dive Deeper!

Resources and Links

1. "T4 Program" accessed May 2022
 https://www.britannica.com/event/T4-Program
2. "Eugenics facts for kids", accessed June 2022
 https://kids.kiddle.co/Eugenics
3. "Aktion T4 – Tiergartenstrasse 4, Berlin, Germany", Landmark Scout accessed June 2022
 https://www.landmarkscout.com/aktion-t4-tiergartenstrasse-4-berlin-germany/
4. "Euthanasia Prevention Coalition", accessed March 2022

https://alexschadenberg.blogspot.com/
5. "Euthanasia in the Netherlands", accessed June 2022
 https://en.wikipedia.org/wiki/Euthanasia_in_the_Netherlands
6. "Euthanasia in Canada", accessed June 2022
 https://en.wikipedia.org/wiki/Euthanasia_in_Canada
7. "Second annual report on Medical Assistance in Dying in Canada" accessed June 2022
 https://www.canada.ca/en/health-canada/services/medical-assistance-dying/annual-report-2020.html#3_1
8. "What is Palliative Care", accessed June 2022
 https://www.virtualhospice.ca/en_US/Main+Site+Navigation/Home/Topics/Topics/What+Is+Palliative+Care_/What+Is+Palliative+Care_.aspx
9. Koop, C. Everett, Francis A. Schaeffer. *Whatever Happened to the Human Race,* Revised Edition, Crossway Publisher, 1983

Scripture and Questions

Deuteronomy 30:19-20
Deuteronomy 5:16
Ephesians 6:1-3
Proverbs 24:10-12
Isaiah 5:20-21

1. How can we love and respect our grandparents and elderly people? More verses to consider: Leviticus 19:32, Psalms 71:18, 92.12-15, Proverbs 16:31 and 1 Timothy 5:17.

2. In what ways can we protect babies, elderly and people with physical and mental needs when our country's laws do not?

3. Can you think of ways you can bless or help the elderly or people with special needs in your family or community?

 According to Leviticus 19:32, Psalms 71:18, 92:12-15, Proverbs 16:31 and 1 Timothy 5:17 how should we treat the elderly?

Chapter 7
THE UNDERGROUND RAILROAD

There is a special people group that our Father loves; remembering them and their struggle is important to continue our understanding of the battle to speak up and honour life. For three hundred years, African people were kidnapped or taken from their homeland across an ocean to an unknown life of slavery. They were treated like non-humans by the greater part of society. Scripture was used in a similar way that Satan used Scripture to tempt Jesus in the wilderness to support the misuse of these precious people (Luke 4:1-13). Once in the Americas, the African people often lived in abusive and horrible conditions. In the midst of this darkness, God's love reached them with the Good News to bring life. John 10:10 says, "The thief cometh not, but for to steal, and to kill, and to destroy: I [Jesus] am come that they might have life…" This life in God's kingdom was evident in the lives of people like Harriett Tubman, Josiah Henson and many others.

. .

NEWS FLASH!!!
HARRIET TUBMAN
By Stan Elliott

Harriett Tubman was born in 1820 into slavery. Her parents named her Araminta which means 'protection'. She escaped to the north in 1849. Starting in 1850, she made 19 trips to the south and back. She freed 300 slaves in her lifetime. She was known for her red bandana and her black bag. Her black bag carried emergency supplies which included a Bible. She was illiterate but knew the value of God's Word. She was a woman led by prayer and strong faith. During the American civil war (1861-1865) she

helped the Union as a spy, a nurse, and a scout. She formed the Harriett Tubman home for elderly black people in 1908 and died in 1913.

Sources: *Harriet Tubman* DK Life Stories by Kitson Jazynka, *If Thine Enemy Thirst*, *The Underground Railroad Reflections* by Janice Huse

• •

The faith and struggle of the African American people made a bridge to God's chosen people and their time of slavery in Egypt which we find in the book of Exodus. The call to freedom rang a chord in Spiritual songs such as 'Let my People Go'. This beautiful song became a code song to move people along to freedom on the Underground Railroad. If the following song was being sung in the work fields, it meant that running slaves should not come out; there was danger in the way.

• •

Let my People Go

Verse 1: When Israel was in Egypt's land; Let my people go!
Oppressed so hard they could not stand; Let My people go!
Refrain: Go down, Moses, Way down in Egypt's land
Tell old Pharaoh: To let My people go
Verse 2: No more shall they in bondage toil; Let My people go!
Let them come out with Egypt's spoil; Let My people go!
Verse 3: Oh, let us all from bondage flee; Let My people go!
And let us all in Christ be free; Let My people go!
Verse 4: You need not always weep and mourn; Let My people go!
And wear these slav'ry chains forlorn; Let My people go!
Verse 5: Your foes shall not before you stand; Let My people go!
And you'll possess fair Canaan's land; Let My people go!
Source: https://library.timelesstruths.org/music/Let_My_People_Go/

• •

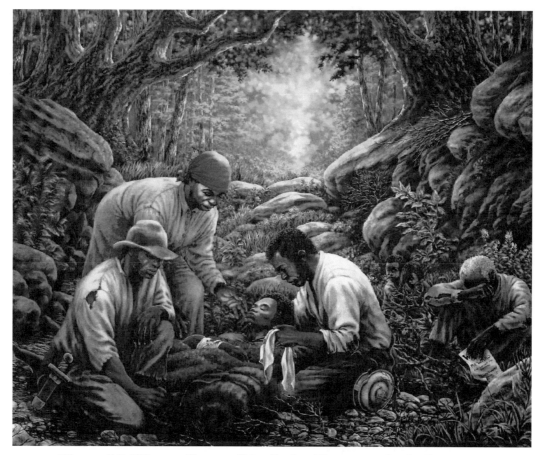

Figure 7.1 "Time to Recover" by Janice Huse <u>www.janicehuse.com</u>

Through the lives and faith of people like Harriett Tubman who kept God's Word close, change came, but sometimes one at a time as she led slaves to freedom. The Underground Railroad had no physical tracks, but it was a strong network of safe houses or stations through many States. The goal was freedom. Each station had a station master who hid the passengers or

slaves. Conductors, like Harriet Tubman, would guide passengers to the next safe house. The goal was to reach Canaan - the code word for Canada. Most travel was done at night so they followed the drinking gourd - a code word to follow the North Star. While passengers were moving along the Underground Railroad at great risk to everyone's life, others were working to change the culture of slavery. It was a massive undertaking to shift a society away from accepting slavery. This took the effort of many individuals to accomplish. William Wilberforce[3] fought in the British Parliament, and the United States fought in the battle fields during the Civil War to free a society from the brutality of enslaving people. Consider for a moment what it would take to shift our society today from accepting the atrocious number of abortions, to accepting and protecting every baby and mother God blesses us with on this earth.

While working with Bert and Willy Dorenbos on the Prayer Train Pro-life Conference that took us to Westerbork and Auschwitz in 2008, we came across the beautiful artwork of Janice Huse. Her Underground Railroad Painting series for *Time* Magazine captures the struggle of the African-American people for their freedom. Out of this connection came a book of Personal Reflections on Janice's paintings called: *'If Thine Enemy Thirst; The Underground Railroad to Freedom'*. The following excerpt is from this book and encourages us to preserve life and even love our enemies. Janice has given permission for two of her paintings to be included in this book along with her Reflection about the painting: 'If Thine Enemy Thirst'.

IF THINE ENEMY THIRST *REFECTIONS by Janice Huse*

Figure 7.2: "If thine enemy thirst" by Janice Huse; www.janicehuse.com

If I had to choose one painting to be my favourite in my entire 38-year career, it would be this one; If Thine Enemy Thirst. It was not originally painted as part of the Underground Railroad Series but has become associated with it from inclusion in public displays of the series.

The scene depicted here could be considered as an epilogue to the Underground Railroad story. It is intentionally displayed as a morality play. A man faces his mortal enemy but chooses to show mercy at the risk of his own life.

The background story as I imagine it is this: the black drummer boy is a former slave who escaped to freedom in the North through the Underground Railroad. He enlists in the Union army at the advent of the Civil War, partly in gratitude for his new found freedom, partly in hopes of helping to liberate enslaved loved ones, and partly because the army offered the rare commodity to an escaped slave of a job with guaranteed food and shelter.

After the heat of a battle, when the troops from both sides have scattered, a black Union drummer boy stumbles across the wounded Confederate soldier. This enemy represents everything that has brought sorrow, heartache, pain and misery to the former slave, all the oppressive horrors of human bondage. Now, made vulnerable by his wounds, the Rebel is an easy target against which the escaped slave can focus his entire wrath. In no other circumstance could a black man legally kill a white man.

But the drama of this situation is even intensified by the fact that a law was passed by the Senate of the Confederate States which called for the mandatory execution on sight of any black Union soldiers. Their becoming a prisoner of war was not an option, as it was for their white counterparts. Death was a certainty mandated by law. So, if the roles in this scene had been reversed, the black soldier would have received no mercy from the white one, and he knew it.

Given these circumstances, all worldly wisdom would dictate that the black Union drummer boy should simply kill the wounded Confederate soldier. But he is a dedicated Christian, and he remembers what he has heard taught from the Bible: "If your enemy is hungry, feed him; if he is thirsty, give him something to drink… do not be overcome by evil, but overcome evil with good." Romans 12:20, 21. "But I say unto you, love your enemies, bless those who curse you, do good to those who hate you, and pray for those who spitefully use you and persecute you." Matthew 5:44.

Thus the decision is made. The young black solder offers his wounded enemy water and spares his life.

It is my belief that this is an important and relevant lesson to us now. If these are indeed the End Times, then, according to Scripture, persecution against Christians will become the most pervasive and brutal of all time. How will we respond when we are reviled, mocked, hated, and hunted for destruction? Will we choose to pray for our enemies, much less show them love and mercy when they threaten us with death? It is my personal belief that the Lord allows us to defend the lives of others. However, when it comes to defending our own life, the New Testament model seems to be one of risking our own lives in order to demonstrate the gospel to our enemies. If we are to walk in that kind of faith in the days ahead, then we must allow the Lord to prepare us now by daily growing us in His character, with the fruits of our lives being those birthed of the Holy Spirit. Now is the time of preparation.

(An excerpt from *If Thine Enemy Thirst: The Underground Railroad to Freedom; Paintings and Reflections*[2])

<u>Dive Deeper!</u>

<u>Resources and Links</u>

1. "Janice Huse artwork", accessed January 2022
 www.janicehuse.com
2. Huse, Janice Northcutt. *If Thine Enemy Thirst: The Underground Railroad to Freedom; Paintings and Reflections.* Cry for Life, Netherlands, 2006
3. Apted, Michael. *Amazing Grace.* Bristol Bay Productions, United Kingdom, 2007
4. Jazynka, Kitson. *Harriet Tubman, DK Life Stories.* Penguin Random House, 2019

5. Editors of TIME for kids. *Time for Kids: Harriet Tubman A woman of courage.* Harper Collins, 2005
6. Henson, Josiah. *The Life of Josiah Henson, Formerly a Slave.* Dover Publications, 2016
7. "Harriet Tubman", accessed May 2022
 www.harriet-tubman.org

Scripture and Questions

Luke 4:1-13
Isaiah 42:3 and Matthew 12:20
Romans 12:20, 21
Matthew 5:44

1. How can we discern like Jesus when Scripture is being misused? Can you give examples of how Scripture could be used to support and argue against the mindset of slavery during the 1800s?

2. If you were in the shoes of the drummer boy from Janice Huse's Reflections could you have done the same? What from God's Word would encourage you?

3. It took a massive effort to stop slavery. What would it take to stop abortion today? What is something your family or group could practically do to contribute to change in our society?

4. As a family or group can you find ways to practically share God's love and peace to people in your community who are from other cultures or people groups?

Going Deeper

1. What do these passages in Revelation 5:8, 7:9-10 and 14:6, 7 tell us about those who will inherit the kingdom of God?

2. What does Jesus' parable about the Good Samaritan in Luke 10:29-37 teach us about showing kindness and compassion to those who consider us their enemies?

3. A stranger or a sojourner is someone from another country who chose to join the people of Israel and worship the God of Israel. How were these refugees and immigrants to be treated, according to Exodus 22:21, 23:9, Leviticus 19:33-34, Deuteronomy 10:17-19 and 24:14-15?

Chapter 8
THE COVENANT OF THE FIRST PEOPLES

• •

Personal Reflection:

As I sat at the entrance of Birkenau contemplating the horrors that took place on these vast grounds during WWII, a woman in our group from Canada approached me. She was an Indigenous woman from Manitoba and was part of our Prayer Train Pro-life conference group. She asked if I would like to hear the Covenant of the First Peoples of Canada. She read and declared the most profound covenant I had ever heard outside of the Bible. If I had not been on the blood soaked grounds of Birkenau I would have cried. After, I wondered where I could get a copy of this Covenant. Twelve years later I found it again and learned that Kenny Blacksmith had written it.

In high school a good friend of mine had grown up with Kenny Blacksmith's children in Mistissini, Northern Quebec. My friend's family lived there for many years where her parents were involved with a Cree Language Project which included literacy, literature and Bible translation in partnership with SIL International, Wycliffe Bible Translators and the Mistissini Band Office. This work resulted in a Cree New Testament published by the Bible Society.

The Covenant of the First Peoples speaks of life and faith in God from a people that the government of Canada tried to change. Below are only three of the statements found in the 'The Covenant

of the First Peoples of Canada'. Permission was granted from Chief Kenny Blacksmith to include the following portion.

The Covenant of
THE FIRST PEOPLES OF CANADA

Whereas the First Peoples of Canada, being First Nations, Inuit and Métis pastors, leaders and community members, hereinafter, the 'First Peoples of Canada' acknowledge the one true God who made the world and everything in it, is the Lord of heaven and earth and that He himself gives all men life and breath and everything else, and that He made every nation of men, to inhabit the whole earth, and that He determined the times set for them and the exact places where they should live, for in Him we live and move and have our being.

> AND WHEREAS the First Peoples of Canada are bound together by the love of Christ and in our common origin, history and experience, and in our faith and hope in God; we are brothers and sisters, leaders and warriors of our nations, purchased and redeemed by the blood of Jesus Christ to be a kingdom and priests to serve our God and reign on the earth.

> Article 1. The First Peoples of Canada hereby affirm to respect, recognize and honour our identity as diverse peoples, and in solidarity to pray for the peace of Jerusalem, and to bless Israel in accordance in the Word of the living God of Abraham, Isaac and Jacob.

The First Peoples of Canada lived on Turtle Island (North America) for generations before European people came exploring. The First Peoples recognize that life is a sacred gift. In every unique people group the family unit and children hold value[1]. There are many books that expand on the unique tribes and lifestyles of the numerous Indigenous people groups of Canada. When European ships landed on the shores of Turtle Island, the way of life for its inhabitants changed forever. Over time many tribes were wiped out, others were segregated and forced onto reserves, and still others blended in with the influx of people from other nations. In the following, select people and places will bring focus on the impact of residential schools in Canada and how our Father in heaven is working to heal and bring restoration to the First People groups of Turtle Island.

In Canada, the federal government officially opened the first residential school in 1880[2]. These government-sponsored, religious schools were an attempt to assimilate the First Peoples' culture with European culture. By the

1920's, Duncan Campbell Scott oversaw the residential schools and mandated attendance for the First Peoples across Canada[3]. He was called out as an extreme assimilationist and pinched pennies at the expense of children's lives and their well-being. Residential schools disrupted the lives and culture of the First Peoples across the country until 1996, when the last school closed. The trauma and abuse caused by the residential schools have come to the forefront in recent years, and overcoming this trauma is a complicated process for those innocent children who have suffered so much pain.

Kenny Blacksmith is a survivor of the residential schools and his painful story can be found in the Resources and Links of this chapter, in an article written by Jonathan van Muran[4]. Children like Kenny were taken from their homes at the young age of five years[5]. Some were taken far away to live at a residential school. They were not allowed to speak their own language or do anything that related to their culture of origin without, often harsh, ramifications. Children like Kenny, whose family lived far from the school, usually did not get to return home till they were sixteen or seventeen years of age!

The First Peoples of Turtle Island, much like the African-American People, have found much inspiration from the sufferings of Israel both in Biblical and modern times. Because of this connection to triumph in the midst of sufferings, and overcoming great odds, Kenny Blacksmith said: "First Nations in Canada have always viewed Israel as the first of all First Nations, and as such, our elder brother. We are truly thankful the word of God is not a 'white-mans' gospel but that it came from another 'Indigenous' people from Israel".

Louise Campbell is a Maskekowak (Swampy Cree) First Nation, 6th generation believer in Jesus Christ and loves the God of Israel. She was a second generation residential school survivor. Unlike Kenny, she did not attend the residential schools. She did assist her mother at times, who was a teacher and taught in the residential schools during Louise's formative years. Her mother's generation went to the residential schools that were run by the Catholic,

Anglican, and other church denominations and were paid for by the Canadian government. Louise's mother had a positive experience, loved learning and was loved by the priests and nuns at the day school she attended. In 1951/52 she became the first Northern Manitoba Cree woman to become a certified teacher and she also taught in the residential schools. However, others in her mother's family suffered from the abuse that typified these schools, and sadly became abusers themselves. As a result, Louise experienced many forms of abuse and repeated torment at the hands of family members. She has forgiven and continues to forgive those who wounded aspects of her life. She is a strong leader, loves God's Word and teaches an engaging, weekly Hebrew letters class for all ages. Led by the Holy Spirit, Louise leads the online class by looking at words in the Bible and their definitions by studying them one Hebrew letter at a time, including the ancient Paleo-Hebrew pictures and their meanings. Each Hebrew letter speaks truth to those who will search their meaning today. Louise is a blessing to many, and her life is a living fulfillment of God's declaration in Isaiah 61:3. The "beauty for ashes" that God has traded for the traumas of her life are evident. Louise's name means 'famous warrior'. She is a second generation residential school overcomer!

Figure 8.1: Frances (nee Apitagon) Campbell (left) Louise Campbell (right)
Photos used with permission

• •

NEWS FLASH!!!
THE SIXTIES SCOOP, 1960S-1980S
By Stan Elliott

The Sixties Scoop was a government program to remove (or 'scoop') Indigenous children from their families without their consent and place them in non-indigenous families. It began in 1951 when an amendment to the Indian Act gave the provinces jurisdiction over Indigenous child welfare. The provinces decided to remove the children from their homes instead of giving their communities needed resources and support. In 1990 the federal government created the First Nations Child and Family Services program that gave First Nation bands the power to administer these services among their own children.

Source: The Canadian Encyclopedia

https://www.thecanadianencyclopedia.ca/en/article/sixties-scoop

• •

THAT WAS THEN...
...THIS IS TODAY.

There are no simple solutions that will remedy the past to change the painful present. Today, the suffering from the Canadian government's attempt to assimilate the unique people groups and their cultures is still deeply felt. The evidence can be unearthed by simply visiting some of the territories/reserves and empty residential schools in their less desirous, remote locations. Documents in the resources and links expound on the poor living conditions, including lack of running water and sewage systems in many communities – many of these

deplorable conditions continue to exist to this day[7]. Many live in overcrowded homes and live below the standard for a Canadian lifestyle.

• •

NEWS FLASH!!!
JORDAN'S PRINCIPLE
By Stan Elliott

Jordan's principle is a program to ensure Indigenous children get the proper care they need. The name comes from Jordan River Anderson, a young Cree boy who needed a lot of medical care. He spent the first two years of his life in the hospital. Doctors said he could go home with support.

Figure 8.2: Photo courtesy of First Nations Child and Family Caring Society [8]

However, the provincial and federal governments argued over who would pay for the support at home. Jordan died at the age of 5, still in the hospital. The principle ensures that every Indigenous child gets the health, education and social support they need so that this never happens again[9].

HIGHLIGHT! 'Bear Witness Day' is on May 10 every year. Invite some friends and have a teddy bear party and remember Jordan River Anderson by telling others about Jordan's principle and the support that all children in Canada, no matter what their ethnicity, can access.

Source: *The Canadian Encyclopedia*
https://www.thecanadianencyclopedia.ca/en/article/jordan-s-principle

• •

Amid the trauma of losing their land and their ways of life, there have been pockets of revival and God bringing His light and truth to the First Peoples of Turtle Island (North America). Kenny Blacksmith recounts an ancient prophecy among many First Nations groups about a people coming with a Black Book (the Bible). The Spokane in the Oregon region feared one God and waited because of a prophecy that spoke of the white man coming with talking leaves (the Bible). Dave and Neta Jackson account this story in their Trailblazer series book called *Exiled to the Red River*[11]. In the midst of the darkness, God's light shines, hope is restored, and lives are changed. Jesus said that the thief comes "to steal, and to kill, and to destroy: I am come that they might have life..." (John 10:10).

The Covenant of the First Peoples of Canada that opened this chapter, was written in 2006 by Kenny Blacksmith and signed by many leading Indigenous people in Canada. This document is a unified declaration among First Nations, Métis and Inuit who came together in agreement to facilitate a tangible process of healing for First Peoples and Canada. Kenny Blacksmith is a humble man who explained how The Covenant of The First Peoples of Canada came into existence:

"In 2006, my wife and I felt led to call a gathering in Ottawa, of First Nations, Inuit and Métis, and whosoever would hear the call. Some 300 people showed up. We had no agenda but to pray and worship for three days.

On the third day, we encountered a baptism of the Father's love. There was forgiveness between the original peoples of Canada, and there was such a foundational healing and freedom from a negative past. The people gathered wanted to set a memorial for this historic gathering, and asked if I would write it down. In prayer, I wrote the Covenant of the First People of Canada."

In 2008, Prime Minister Stephen Harper made a statement of apology on behalf of the Canadian Government to former students of the residential schools. Most recently in April 2022, Métis, First Nations and Inuit people went before the Pope and received an apology for the contribution made by the

Roman Catholic Church. The Covenant of the First Peoples of Canada and the apology in 2008 was followed by another document called, *The Charter of Forgiveness and Freedom.* Kenny wrote this charter on behalf of those who are willing to forgive. Confession and forgiveness with Jesus as the centre provides the healing that the people and the land need to live out God's divine order by His Holy Spirit. Kenny Blacksmith made a beautiful statement in his interview[4]: "Let's give God a chance - He knows how to make things better. Canada belongs to God."

Our Father does care and He is moving among the First Peoples spiritually and physically. The First People of Canada have suffered and there is much pain and despair but in the midst of the suffering are life stories from Kenny Blacksmith and Louise Campbell and others that demonstrate that the light always pierces the darkness. Their story of victory brings Isaiah 61:3 to life. May it be a prayer for Israel and the First Peoples of Canada and for all those weary from the battle.

Isaiah 61:3 "To appoint unto them that mourn in Zion, to give unto them beauty for ashes, the oil of joy for mourning, the garment of praise for the spirit of heaviness, that they might be called trees of righteousness, the planting of the LORD, that He might be glorified"

• •

Figure 8.4: "Trees of Righteousness" by Sheryl Ann Art

Dive Deeper!

Resources and Links

1. Silvey, Diane. *The Kids Book of Aboriginal People In Canada.* Kids Can Press, 2005
2. "Residential schools in Canada", The Canadian Encyclopedia, accessed May 2022

 https://www.thecanadianencyclopedia.ca/en/article/residential-schools

3. "Until there is not a single Indian in Canada", Facing History and Ourselves, accessed July 2022 https://www.facinghistory.org/en-ca/resource-library/until-there -not-single-indian-canada

4. "The Spiritual Solution to Residential Schools", Jonathon van Muran (interview with Kenny Blacksmith), accessed November 2022, https://www.convivium.ca/articles/the-spiritual-solution-to-residential-scho ols/

5. Loyle, Larry. *As Long as the Rivers Flow*. Groundwood Books, 2005

6. Vardy, Belma. *Because God was There*. Castle Quay Books, 2017

7. "FACT SHEET - Quality of Life of First Nations June 2011", Assembly of First Nations, accessed May 2022, https://www.afn.ca/uploads/files/factsheets/quality_of_life_final_fe.pdf

8. "First Nations Child and Family Caring Society", accessed December 2022, https://fncaringsociety.com/home

9. "Jordan's Principle, the story of Jordan River Anderson", accessed November 2022, https://www.youtube.com/watch?v=aGAvqRigxko

10. "Jordan's Principle", The Canadian Encyclopedia, accessed November 2022, https://www.thecanadianencyclopedia.ca/en/article/jordan-s-principle

11. Jackson, Dave and Neta. *Exiled to the Red River: Introducing Chief Spokane Garry* (Trailblazer series). Castle Rock Creative, 2016

Scripture and Questions

Isaiah 54:10
Hebrews 13:20
Isaiah 61:3
John 10:10

1. There are a number of Covenants in the Bible; can you find some that God made with His people?

2. What are some characteristics of these Covenants? What do they tell us about God and our relationship with Him?

3. John 10:10 is a theme through the stories of people and places in this book. How did the thief act among the First People of Turtle Island and how did Jesus bring them life?

4. What can you do practically as a family or group to bless the First People of Turtle Island? Find a meaningful way to connect with them.

Going Deeper

1. The beauty spoken of in Isaiah 61:3 in the phrase, "beauty for ashes" is the Hebrew word "pe'er" (Strong's H6287). It is a unique word that means much more than just beauty. It is an elaborate head-dress or turban worn by priests and men in leadership positions. Later in the same chapter, in verse 10 it refers to the beautiful head-dress of the bridegroom on his wedding day. How does this relate to the

Indigenous people, when you think of the beautiful, elaborate head-dresses worn by chiefs, and elders?

2. In Jeremiah 30:16-22 we see a beautiful promise regarding the healing and restoration of the house of Jacob. How can this promise be applied to the First Peoples of Turtle Island who put their trust in the God of Jacob?

Chapter 9

SPEAK UP FOR LIFE

Speak Up for Life is a life-long journey to encourage and challenge believers to speak up for the least, the lost, the broken and the forsaken. It is a journey that is travelled with God's Holy Spirit living in us. It is a way of life that can be lived when we speak His words and act in His way as His only Son, Jesus, did while He lived on this earth.

Our Father in heaven loves life abundantly! What can we do but speak up and act for life. Remember the past by learning about people like Corrie ten Boom, Harriett Tubman and Kenny Blacksmith who came to love the Living God and His people Israel. Remember the places where lives were changed and protected though trials. As He leads us, we who belong to Him exist as His hands and feet today to rescue those in the paths that lead to death. He calls us to love and respect the little ones in the womb. Mothers and babies need to hear His hope in our words each day. As we love and listen to the wisdom of the elderly, we can stay close to them as they leave this present life. We can listen to and respect people who have been marginalized and bless them with our presence and listening to their story. Living with His Spirit, we can walk in our Father's Word and in His Ways each day as Jesus taught us to live. We are called to stand in the gap and pray for the Jewish people to receive Jesus as their Messiah. The restoration of everything is coming (Acts 3:21). He will accomplish and perform His Word to complete His purpose. Our Father's Word does not return to Him empty but accomplishes what He sent it forth to do.

Isaiah 56:11 "So shall my word be that goes forth out of my mouth: it shall not return unto me void, but it shall accomplish that which I please and it shall prosper in the thing where I sent it."

Dive Deeper!

Scripture and Questions

1 Thessalonians 5:14-21
Proverbs 31:8, 9

1. How can we put each of these directions from 1 Thessalonians into practice on a daily basis?

2. How will doing this help us be led by the Holy Spirit to help others?

3. The passage in Proverbs encourages us to 'Speak up'. Who are we to speak up for?

4. Which person or place from this book encouraged you to 'Speak up' and how?

Going Deeper

1. How does the parable Jesus told in Matthew 25:31-46 motivate us to 'Speak up' for the 'least of these my brethren'?

2. What is the key to the salvation of many people according to 2 Corinthians 1:6?

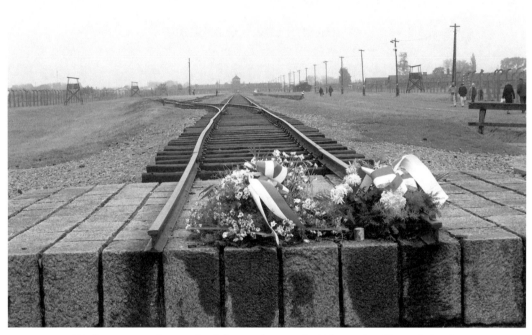

Birkenau at the end of the train track (Photo by Sheryl Ende)

About the Author

Sheryl's animated storytelling is enjoyed by children of all ages. Her desire to see children thrive led her to earn a degree in Family and Social Relations and later a Bachelor of Education. Sheryl completed a Children's Literature Writing course and started freelance editing in 2007 while living in The Netherlands. She enjoyed travelling to places like Israel and is now residing in Eastern Ontario. She provides her children with an eclectic home education and loves the outdoors, painting, and bringing smiles to children with her stories.

Compilation Books by Sheryl Ende:
Their Gift of Life, Life after an abortion, Testimonies from around the World, Cry for Life, Netherlands, 2007

Looking Inside, Testimonies from around the World, Cry for Life, Netherlands, 2009

Peripheral Visions of Paradise, Booklet, Cry for Life, Netherlands, 2015

Remember Me…, Stories to Comfort those Walking through Miscarriage and Infant Loss, Compiled by Sheryl Ende, e-book, 2022

Printed in the United States
by Baker & Taylor Publisher Services